DRAW, MODEL, & PAINT

DRAWING DINOSAURS

by Isidro Sánchez
Illustrations by Vicenç Ballestar
Photographs by Juan Carlos Martínez

Gareth Stevens Publishing
MILWAUKEE

For a free color catalog describing Gareth Stevens' list of high-quality books, call 1-800-542-2595 (USA) or 1-800-461-9120 (Canada). Gareth Stevens' Fax: 414-225-0377.

Library of Congress Cataloging-in-Publication Data

Sánchez, Isidro.
 [Dibuja dinosaurios. English]
 Drawing dinosaurs / text by Isidro Sánchez ; drawings by Vicenç Ballestar ;
photography by Juan Carlos Martínez.
 p. cm. — (Draw, model, and paint)
 Includes index.
 Summary: Presents step-by-step instructions for drawing dinosaurs; also describes
the supplies needed and the best techniques to use.
 ISBN 0-8368-1519-X (lib. bdg.)
 1. Colored pencil drawing—Technique—Juvenile literature. 2. Dinosaurs in art—
Juvenile literature. 3. Dinosaurs—Juvenile literature. [1. Colored pencil drawing—
Technique. 2. Drawing—Technique. 3. Dinosaurs in art. 4. Dinosaurs.] I. Ballestar,
Vincenç, ill. II. Martínez, Juan Carlos, 1944- ill. III. Title. IV. Series.
NC892.S2413 1996
743'.6—dc20 95-45074

This North American edition first published in 1996 by
Gareth Stevens Publishing
1555 North RiverCenter Drive, Suite 201
Milwaukee, Wisconsin 53212, USA

Original edition © 1994 Ediciones Este, S.A., Barcelona, Spain, under the title
Dibuja Dinosaurios. Text by Isidro Sánchez. Drawings by Vicenç Ballestar.
Photography by Juan Carlos Martínez. All additional material supplied for
this edition © 1996 by Gareth Stevens, Inc.

Series editor: Barbara J. Behm
Editorial assistants: Jamie Daniel, Diane Laska, Rita Reitci

Printed in the United States of America

1 2 3 4 5 6 7 8 9 99 98 97 96

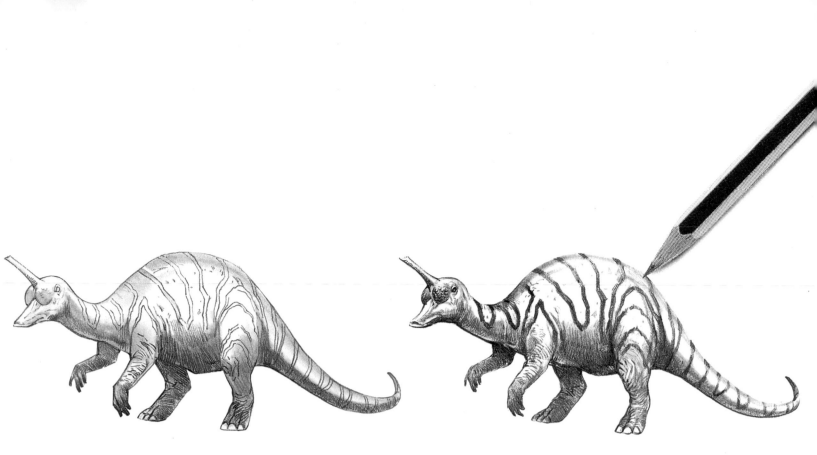

CONTENTS

Media for drawing. **4**

Drawing with pencils. **6**

A gigantic Brachiosaurus **8**

A tremendous Tsintaosaurus **12**

An enormous Iguanodon **16**

A ferocious Velociraptor **20**

A stupendous Stygimoloch **24**

A dinosaur fight! **28**

Glossary. **32**

Books and Videos for Further Study **32**

Index . **32**

Media for drawing

A medium is the material and style an artist uses. In this book, you will draw dinosaurs with basic lead pencils and colored pencils. You will also discover fascinating details about the dinosaurs you draw, such as when and where they lived, how big they were, what they ate, and how they defended themselves from enemies.

Colored pencils come in light and dark shades of the same color.

Basic pencils

A basic pencil – a lead pencil – is made of a mixture of graphite and clay. Pencil leads can be either hard, medium, or soft, depending on the amount of graphite and clay used in the mixture. The hardness or softness of the lead is indicated by numbers on the side of the pencil. Hard-lead pencils (such as #3) are used for drawing light tones. Medium-lead pencils (such as #2) are used for drawing gray tones. Soft-lead pencils (such as #1) are used for drawing dark, black tones.

Colored pencils

Unlike basic pencils, the leads of colored pencils are made of a mixture of color pigments and clay. Colored pencils are not made with harder or softer leads; they are all the same firmness. For this reason, they supply the same degree of color. In art supply stores, you can find colored pencil sets with as many as 120 different colors. A set of about 12 colored pencils will be enough to enable you to color the dinosaurs in this book. Your colored-pencil set should include dark and light shades.

An eraser is used for "drawing" as well as erasing. To draw with an eraser, gently rub the eraser over pencil lines to soften the tones and create white patches. This process is called "stumping." When you look at the pictures in this book, you will be able to see the stumping.

A paper stump (blending stump) can also be very useful.

A pencil sharpener like this is the safest and best way to keep your pencils sharp.

With a paper stump, spread the lead evenly over the drawing. This results in a smooth change from a soft tone to a harder tone, or from a hard tone to a softer one.

For the projects in this book, you will need a medium-lead pencil for drawing grays, and a soft-lead pencil for drawing dark, black lines.

Pencils with hard leads are not often used for drawing because the lines they make are difficult to erase.

Drawing with pencils

Basic pencils

When drawing lines, hold the pencil a little farther up from where you hold it to write. When shading an area of your drawing, turn the pencil slightly sideways and draw with the flat part of the lead. Drawing with the tip of the pencil will produce fine lines. Drawing with the flat side will give you thicker lines. The thickness of the lines will also depend on how hard you press.

CROSSHATCHED LINES

Shading is a way to gradually blend lines together. In this illustration, shading has been done by crosshatching and stumping.

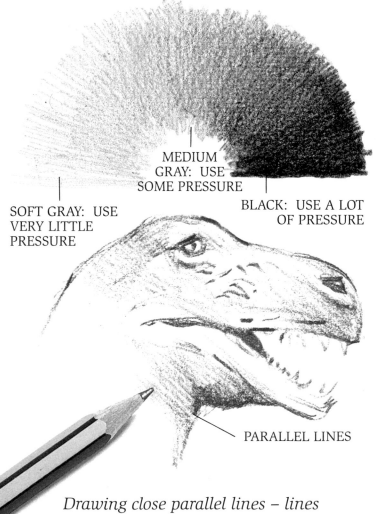

MEDIUM GRAY: USE SOME PRESSURE

SOFT GRAY: USE VERY LITTLE PRESSURE

BLACK: USE A LOT OF PRESSURE

PARALLEL LINES

Drawing close parallel lines – lines that run evenly alongside one another – can also create shading.

To shade using crosshatching, first draw parallel lines in one direction. Then, depending on how dark a shadow needed, add additional lines that run in a different direction over the top of the first lines.

You can also shade by drawing zigzag lines closely together, pressing down firmly at first and then slowly reducing the pressure.

A pencil will not cover on the surface of the to spread the lead of your drawing is

all the tiny bumps paper. The best way evenly over the surface to use a paper stump.

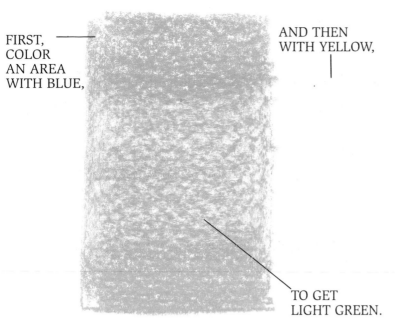

FIRST, COLOR AN AREA WITH BLUE,

AND THEN WITH YELLOW,

TO GET LIGHT GREEN.

Colored pencils

Use the pointed tip of a colored pencil to draw lines. Use the side for coloring in wider areas. One way to blend different colors is to press down firmly on the pencil and draw zigzag lines closely together, and then gradually reduce the pressure. One thing to keep in mind when using colored pencils is that light colors do not cover dark ones. If you color a light color over a darker one, the darker color will show through.

Sometimes you will have to mix colors to get just the color you want. By coloring first with one color and then adding another color over it, you will be able to make a third color. In this illustration, coloring with blue and then adding yellow over it makes light green.

YOU CAN ALSO USE COLORED PENCILS TO MAKE CROSSHATCHED AREAS.

IF YOU COLOR A LIGHT COLOR OVER A DARKER ONE, THE DARKER COLOR WILL SHOW THROUGH.

Crosshatching with colored pencils is done in the same way as with basic pencils. If you press hard on the pencil, the tone is darker and more intense. In the drawing on the right, a color blend has been made by crosshatching blue over yellow.

PARALLEL LINES

DRAW PARALLEL LINES BY HOLDING THE PENCIL AT AN ANGLE.

A gigantic Brachiosaurus

1. With a medium pencil, draw the main outline of Brachiosaurus shown below.

2. Draw in the details of the neck, feet, and face.

Shade by pressing hard on your pencil, making parallel lines.

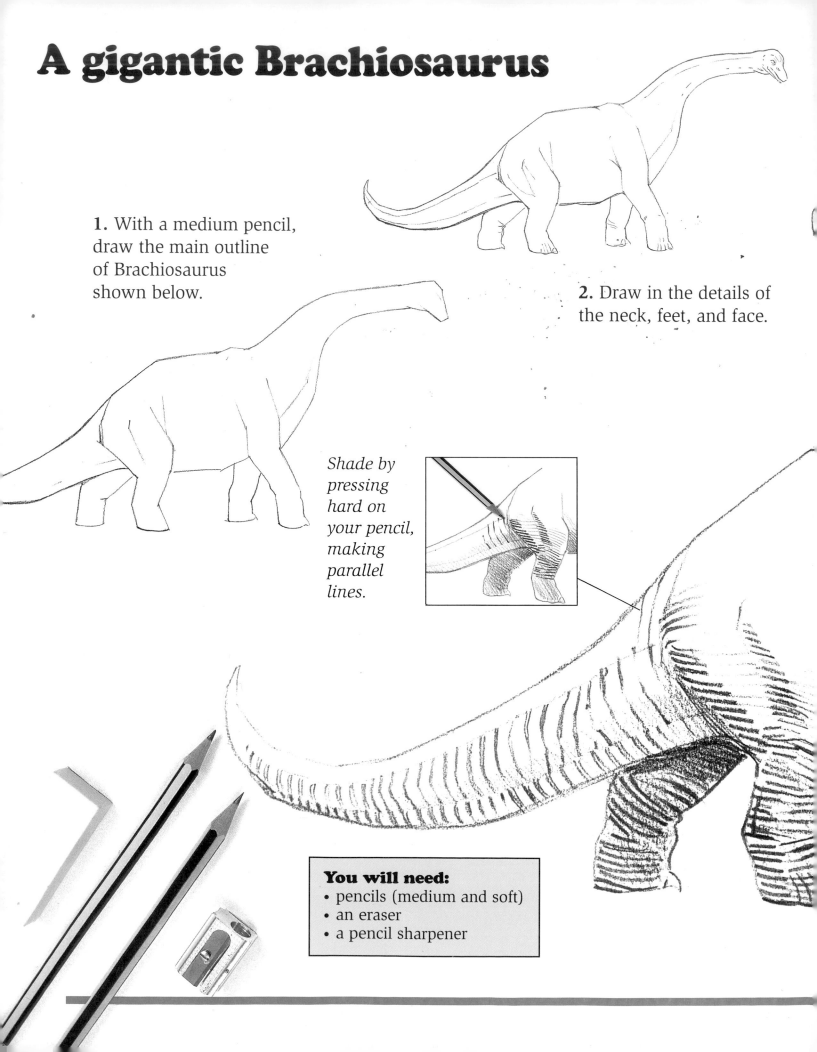

You will need:
- pencils (medium and soft)
- an eraser
- a pencil sharpener

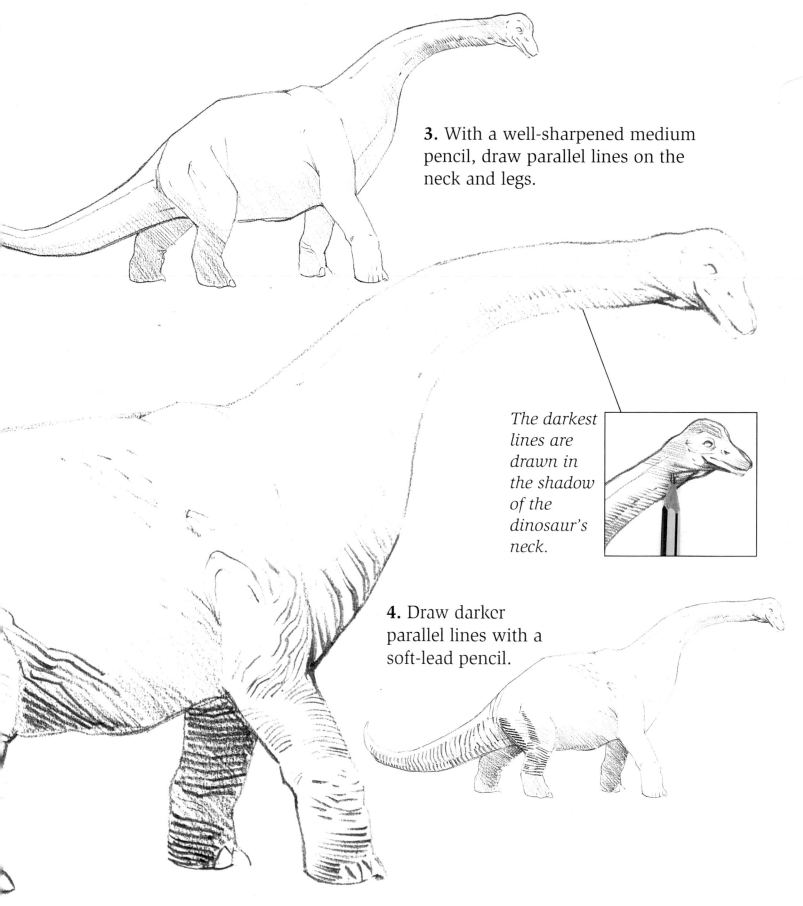

3. With a well-sharpened medium pencil, draw parallel lines on the neck and legs.

The darkest lines are drawn in the shadow of the dinosaur's neck.

4. Draw darker parallel lines with a soft-lead pencil.

5. In the areas of the dinosaur that are in shadows, draw the parallel lines even darker.

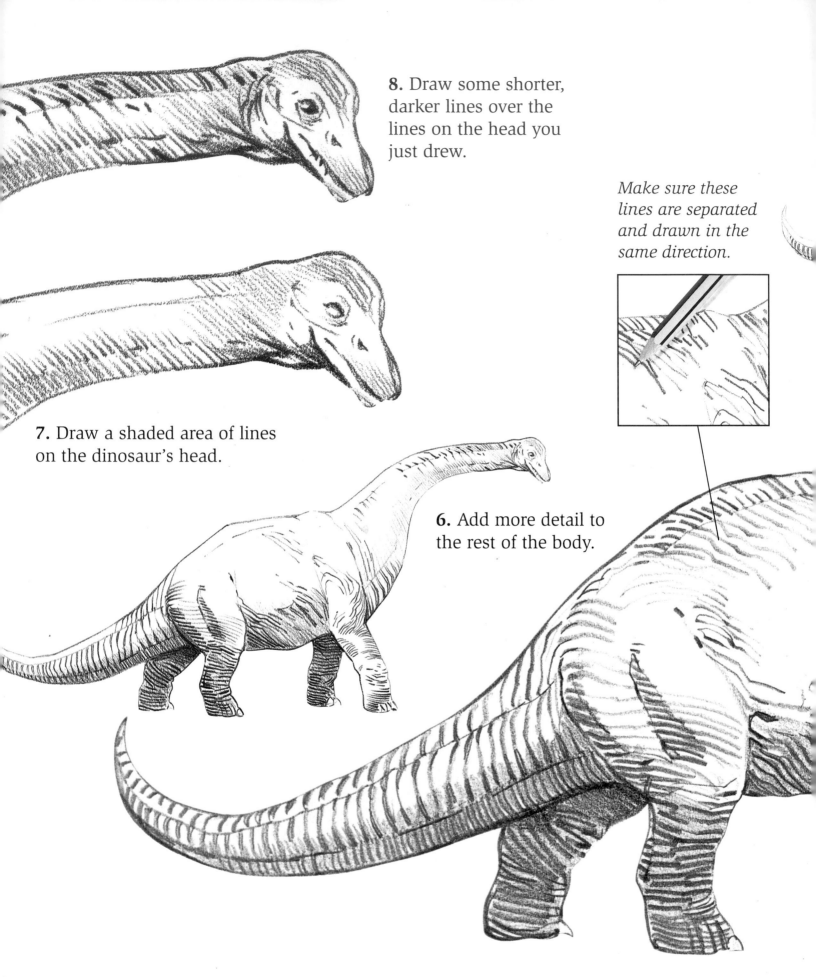

8. Draw some shorter, darker lines over the lines on the head you just drew.

Make sure these lines are separated and drawn in the same direction.

7. Draw a shaded area of lines on the dinosaur's head.

6. Add more detail to the rest of the body.

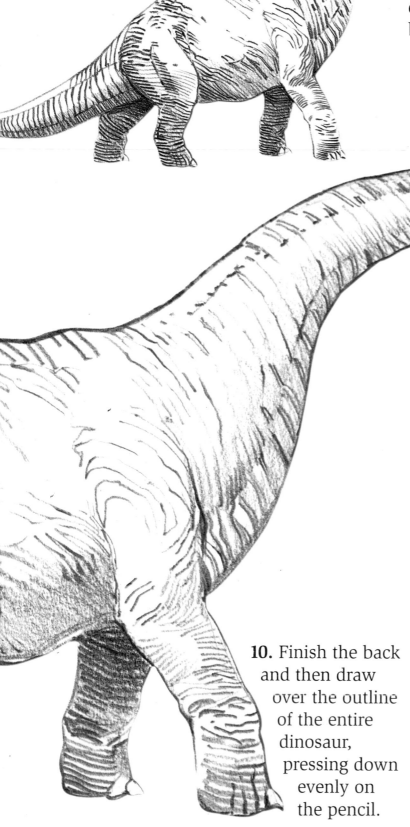

9. Continue to draw short, dark lines on the neck and back of Brachiosaurus.

10. Finish the back and then draw over the outline of the entire dinosaur, pressing down evenly on the pencil.

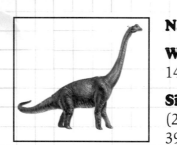

Name: Brachiosaurus

When it lived: About 145 million years ago

Size: 75 feet (23 meters) long; 39 feet (12 m) tall

Where it lived: Africa, North America

Characteristics: Brachiosaurus was one of the largest and heaviest dinosaurs. It was as tall as a four-story building and weighed as much as ten elephants. Its neck alone was 20 feet (6 m) long, but it supported a comparatively small head. Every day it ate enormous quantities of leaves (about ten times what an elephant eats) to give its huge body energy.

A tremendous Tsintaosaurus

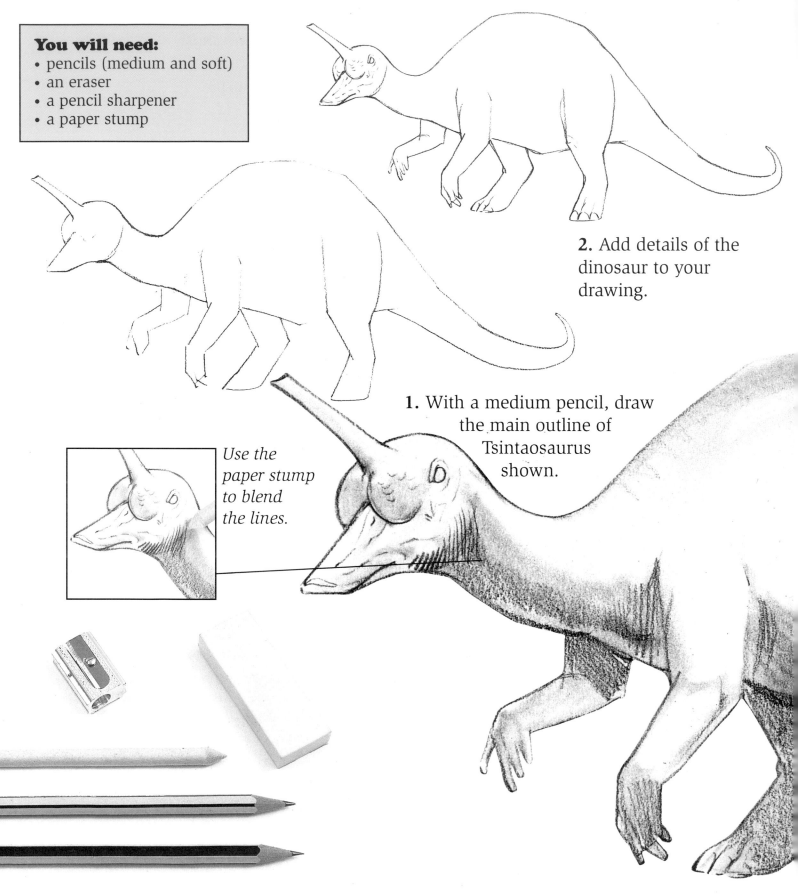

You will need:
- pencils (medium and soft)
- an eraser
- a pencil sharpener
- a paper stump

2. Add details of the dinosaur to your drawing.

1. With a medium pencil, draw the main outline of Tsintaosaurus shown.

Use the paper stump to blend the lines.

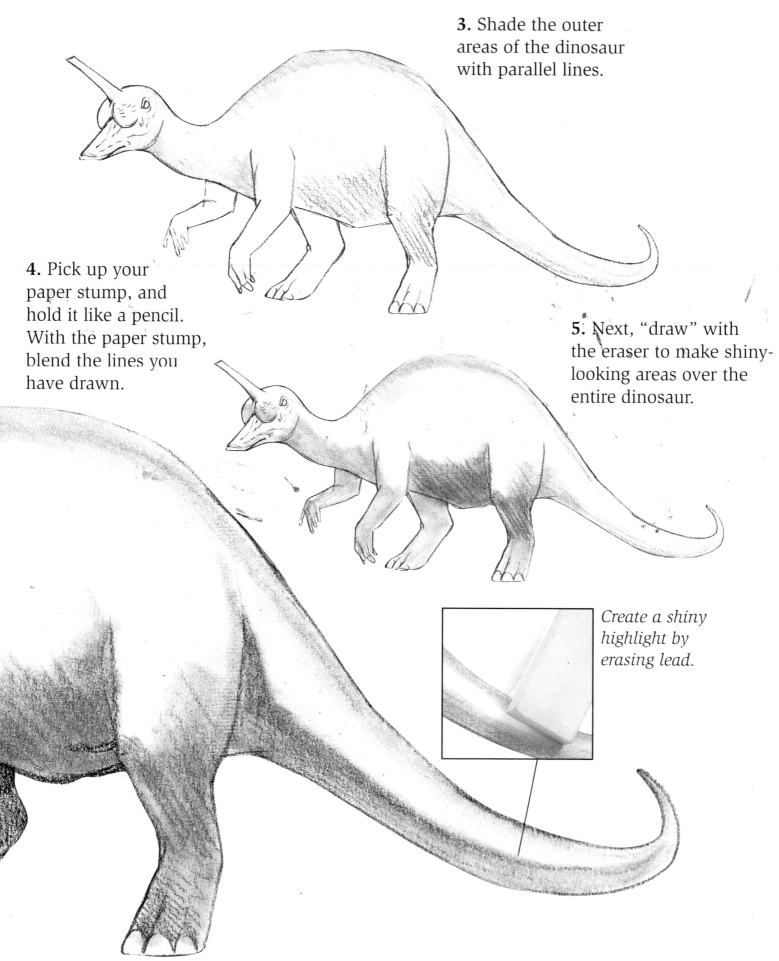

3. Shade the outer areas of the dinosaur with parallel lines.

4. Pick up your paper stump, and hold it like a pencil. With the paper stump, blend the lines you have drawn.

5. Next, "draw" with the eraser to make shiny-looking areas over the entire dinosaur.

Create a shiny highlight by erasing lead.

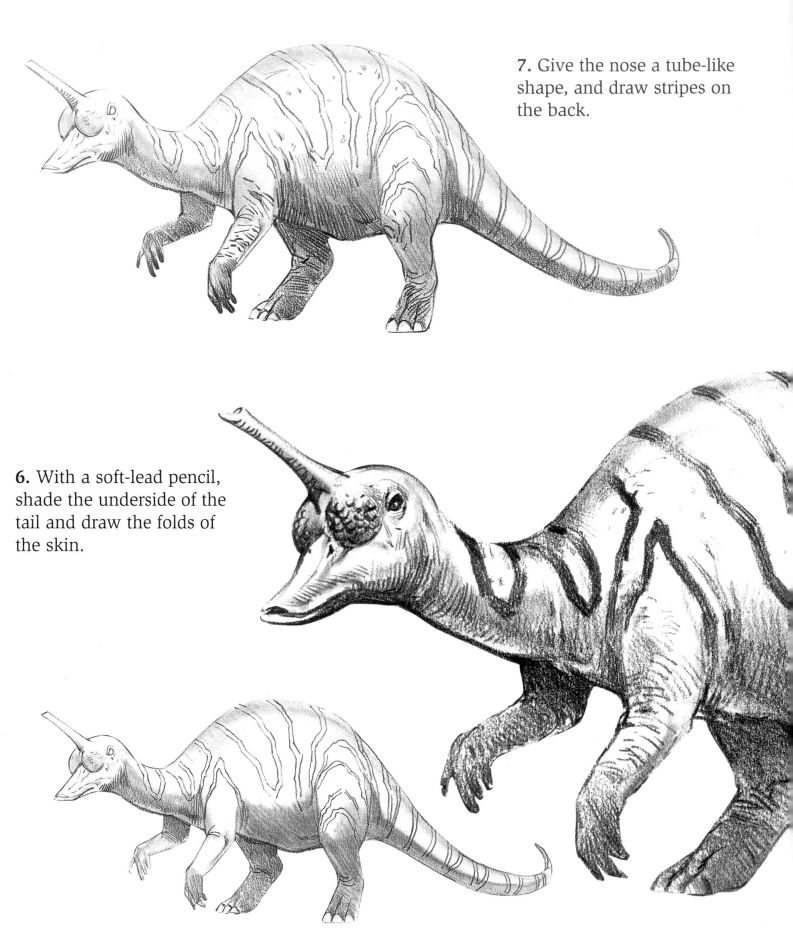

7. Give the nose a tube-like shape, and draw stripes on the back.

6. With a soft-lead pencil, shade the underside of the tail and draw the folds of the skin.

8. Fill in the stripes using a well-sharpened medium-lead pencil. Press down firmly.

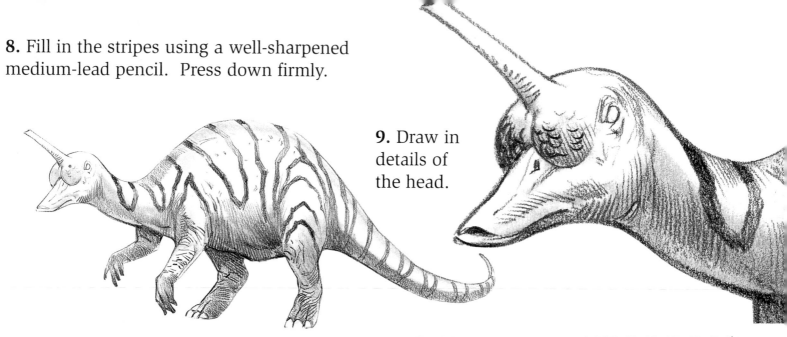

9. Draw in details of the head.

10. To complete the drawing, use your paper stump to blend areas of the mid-body, tail, neck, and head.

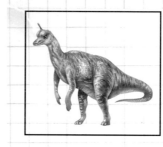

Name: Tsintaosaurus

When it lived: About 88 to 65 million years ago

Size: 33 feet (10 m) long; 20 feet (6 m) tall

Where it lived: China

Characteristics: Tsintaosaurus was as long as an elephant and as tall as a two-story building. It was a herbivore, eating only plants. It had several rows of teeth on either side of its mouth for chewing vegetation. The male had a horn on the top of its head for attracting females.

Make the folds of the skin with parallel lines.

An enormous Iguanodon

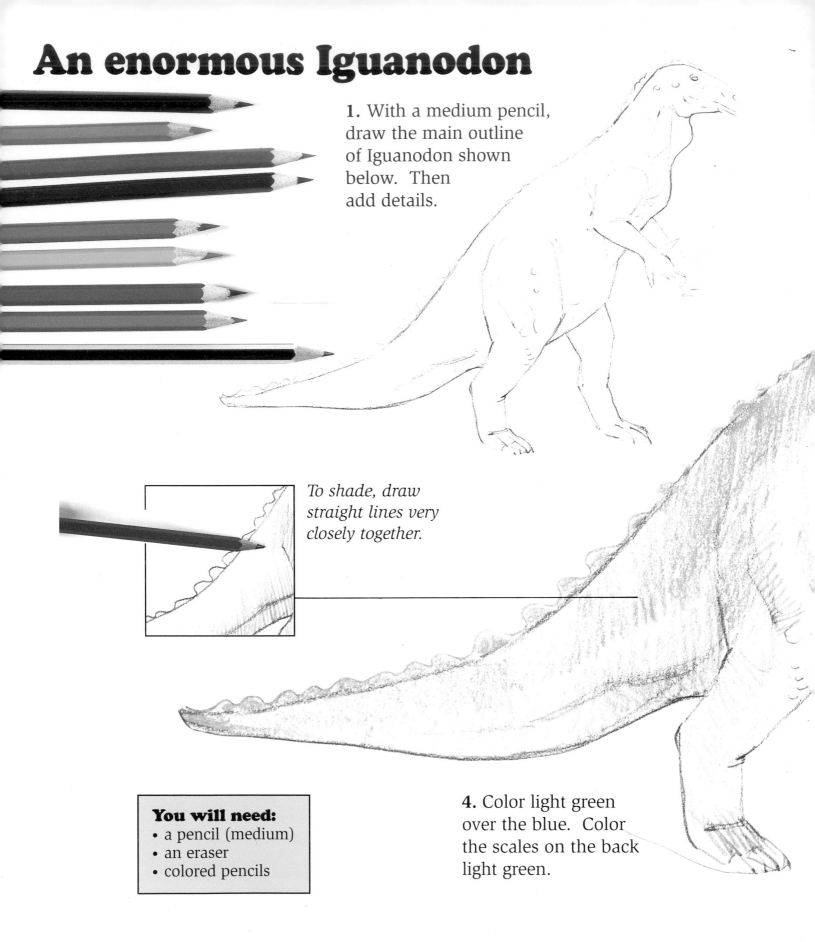

1. With a medium pencil, draw the main outline of Iguanodon shown below. Then add details.

To shade, draw straight lines very closely together.

You will need:
• a pencil (medium)
• an eraser
• colored pencils

4. Color light green over the blue. Color the scales on the back light green.

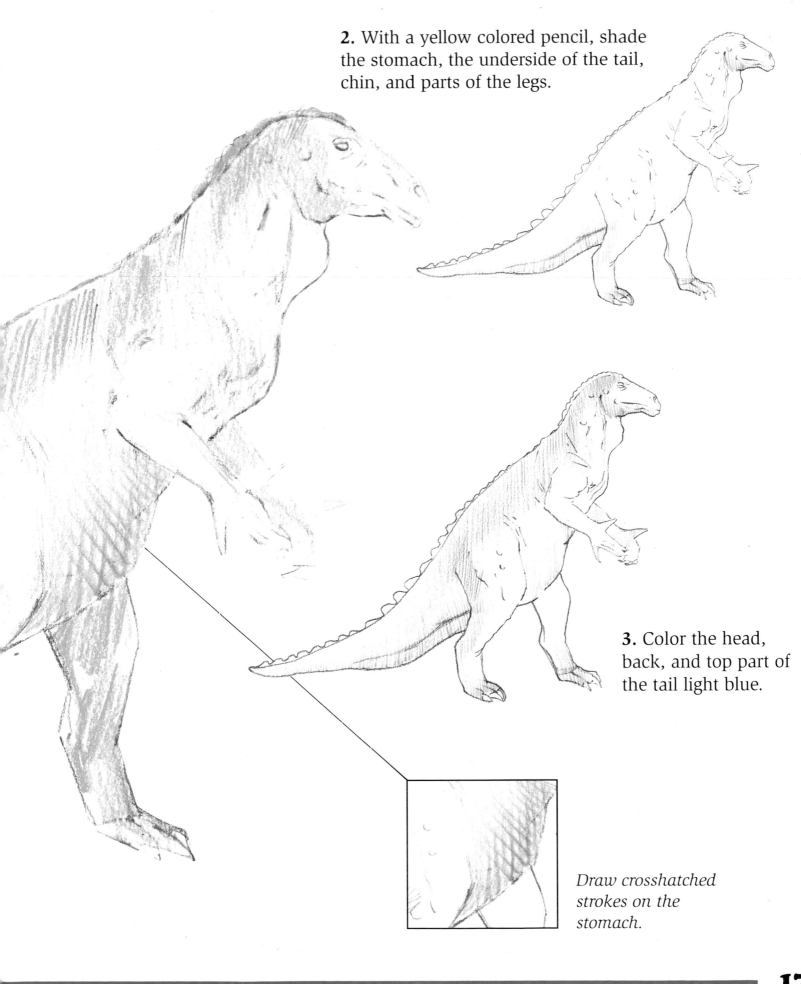

2. With a yellow colored pencil, shade the stomach, the underside of the tail, chin, and parts of the legs.

3. Color the head, back, and top part of the tail light blue.

Draw crosshatched strokes on the stomach.

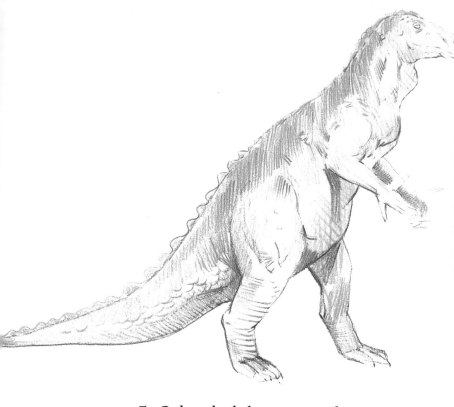

6. Draw dark blue lines on the top half of the head and back. Use dark blue to shade some areas of the legs.

5. Color dark brown on the stomach, feet, and lower part of the tail. Also, use light brown on the stomach, legs, and tail.

The dark blue lines should fade as you get nearer the tip of the tail.

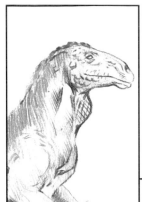

Add details to Iguanodon's head.

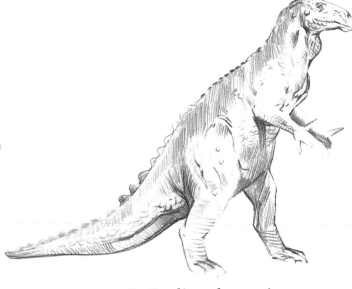

7. Outline the entire dinosaur with dark brown.

8. Add dark green to the back and underside of the tail. Go over the shaded areas and the outline with black.

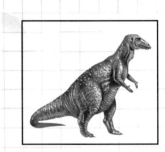

Name: Iguanodon

When it lived: Between 125 and 105 million years ago

Size: 33 feet (10 m) long; 16 feet (5 m) tall

Where it lived: Europe, North America, Africa, Asia, Romania, and Mongolia

Characteristics: The first dinosaur fossil ever found was that of Iguanodon. It was discovered in 1834, when people did not know that dinosaurs had ever existed. Each of its "hands" had a sharp, clawlike spur for self-defense.

A ferocious Velociraptor

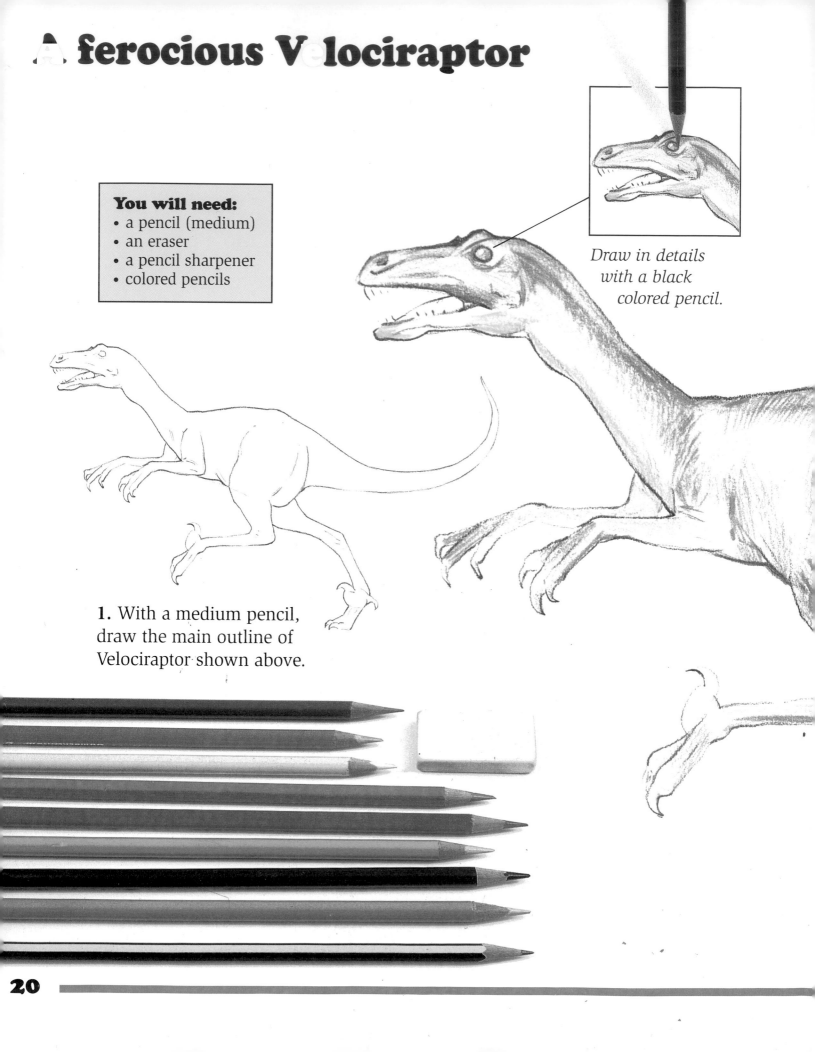

You will need:
- a pencil (medium)
- an eraser
- a pencil sharpener
- colored pencils

Draw in details with a black colored pencil.

1. With a medium pencil, draw the main outline of Velociraptor shown above.

2. Hold the yellow pencil at an angle, and shade very softly.

3. Use light blue to shade the underside of the dinosaur. Color all the lines in the same direction.

Draw orange lines over the yellow.

4. Darken the head, neck, back, and tail with orange.

5. Draw in dark brown lines where extra detail or shading is needed. Do this with a well-sharpened pencil so the lines are as thin as possible.

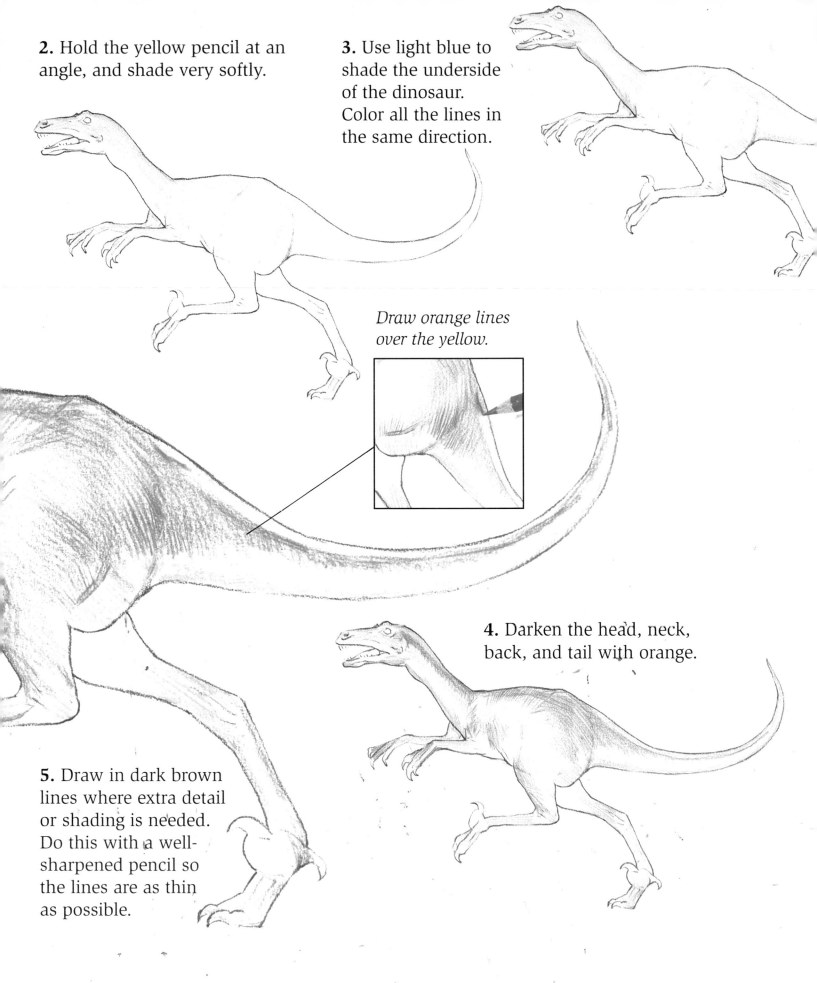

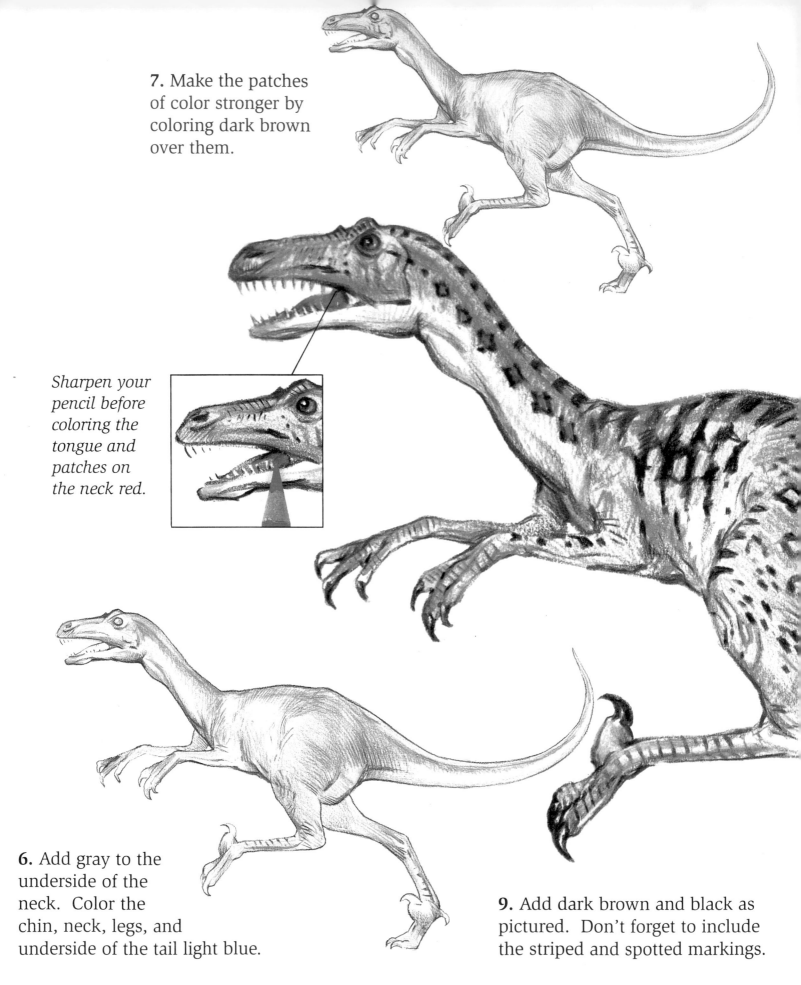

7. Make the patches of color stronger by coloring dark brown over them.

Sharpen your pencil before coloring the tongue and patches on the neck red.

6. Add gray to the underside of the neck. Color the chin, neck, legs, and underside of the tail light blue.

9. Add dark brown and black as pictured. Don't forget to include the striped and spotted markings.

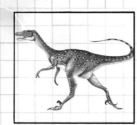

Name: Velociraptor

When it lived: About 90 million years ago

Size: 6.5 feet (2 m) long

Where it lived: Mongolia

Characteristics: Velociraptor was small, but mighty. Larger dinosaurs were afraid of it. Prey had little chance of escaping Velociraptor's deadly claws. This dinosaur also had long, sharp teeth. It hunted in groups. Velociraptor kept its balance by raising and lowering its tail.

8. Add details to the head with black.

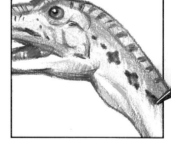

On the neck, draw black over red.

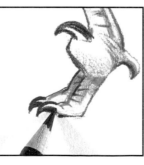

Outline the claws with black.

A stupendous Stygimoloch

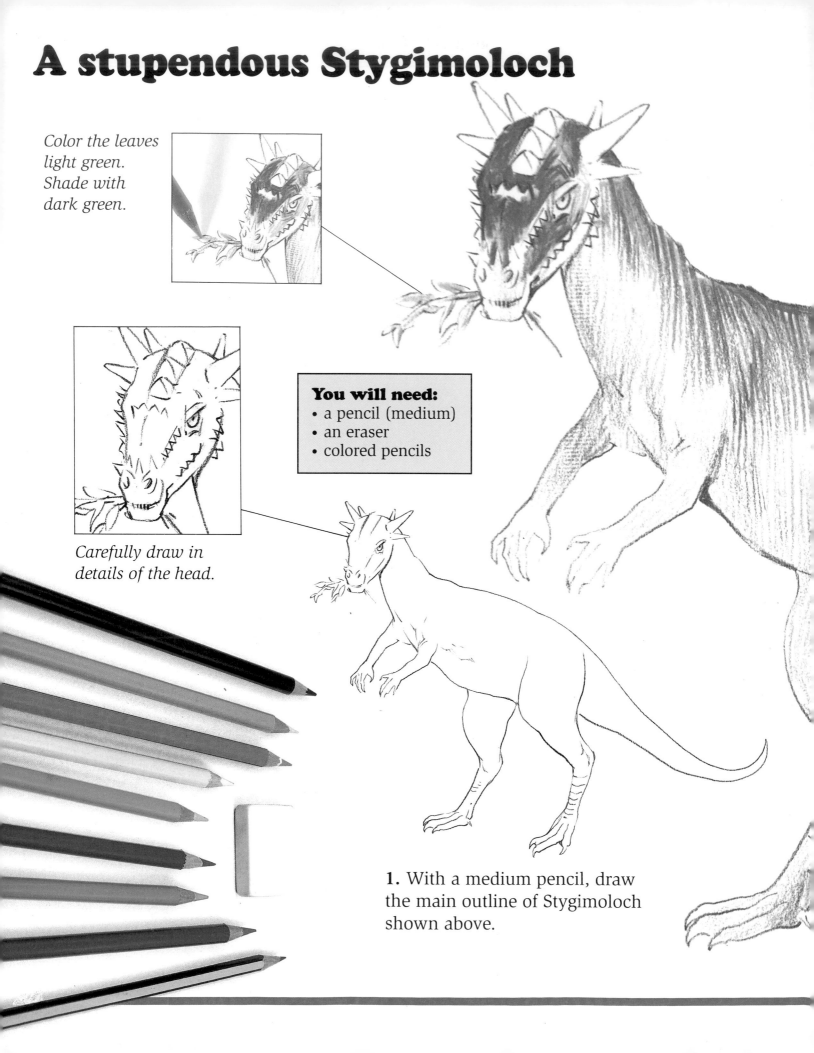

Color the leaves light green. Shade with dark green.

Carefully draw in details of the head.

You will need:
- a pencil (medium)
- an eraser
- colored pencils

1. With a medium pencil, draw the main outline of Stygimoloch shown above.

2. Color the upper areas of the dinosaur with light blue. Color all the lines in the same direction.

3. Shade the lower body with gray.

Dark blue makes a good contrast against light blue.

4. Color some orange over the gray.

5. Add dark blue to the back and head.

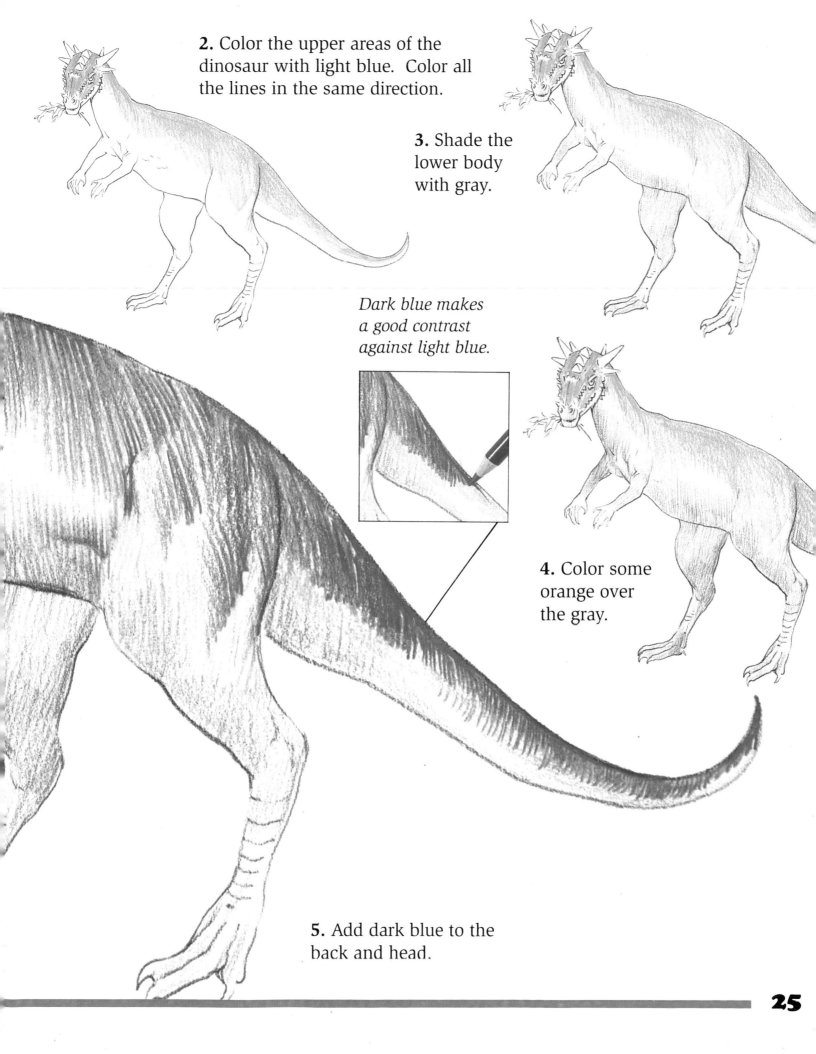

Shade the horns using parallel strokes of the gray pencil.

7. Color the inside of the eye with the yellow pencil. Color the horns gray. Draw the folds of the legs with dark brown.

6. Color some pink on the stomach. Then darken the pink with gray.

8. Outline the leaves in the dinosaur's mouth in black. Then outline the features on the face with black.

Name: Stygimoloch

When it lived: About 75 million years ago

Size: 10 feet (3 m) long; 6.5 feet (2 m) tall

Where it lived: North America

Characteristics: The Stygimoloch was a small herbivore that walked on its hind legs. This made it possible for it to reach up to eat the leaves of trees. Stygimoloch had several strong, pointed horns on its head that were very sharp. Scientists think that the males may have used these horns to fight off rivals.

9. Outline the entire dinosaur in black.

10. Shade areas on the underside of the dinosaur with dark gray.

A dinosaur fight!

Keep your pencil at an angle while drawing these parallel, separated lines.

1. With a medium pencil, draw the main outlines of the two fighting dinosaurs shown above.

You will need:
- a pencil (medium)
- an eraser
- colored pencils

2. Hold the yellow pencil at an angle and shade the areas shown. Color in some ocher, using the tip of the pencil.

3. Fill in the areas shown with light gray. Do this by drawing in faint lines, all in the same direction.

Fill in any empty spaces by crosshatching with yellow.

4. For the dinosaur on the left, color dark gray over the light gray. For the dinosaur on the right, highlight areas of the back with gray, and add gray to the feet.

6. Draw more gray lines on the dinosaur on the left. Add some very faint green to the armor plating on the dinosaur on the right. Color the eyes.

5. Draw blue over gray on the dinosaur on the left. Add some dark brown to the back and legs of the dinosaur on the right.

Make these small markings with the sharpened tip of your dark blue pencil.

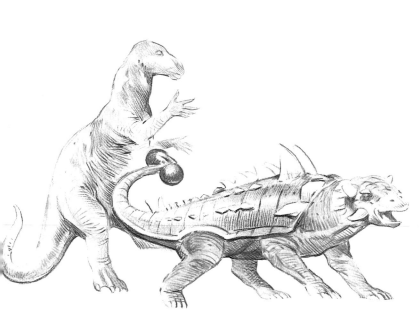

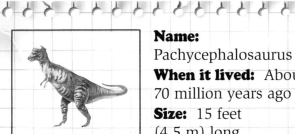

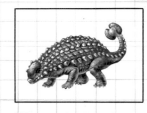

Name:
Pachycephalosaurus
When it lived: About
70 million years ago
Size: 15 feet
(4.5 m) long
Where it lived: North America
Characteristics: It used its head as a
battering ram when fighting.

Name: Ankylosaurus
When it lived: About
70 million years ago
Size: 35 feet
(10.7 m) long
Where it lived: North America
Characteristics: Ankylosaurus had bony
plates and sharp spines. It also had a club
on its tail for self-defense.

7. Color the stomach of the dinosaur on the right with soft strokes of orange. Mark the folds in the skin of the dinosaur on the left with black.

Note the different colors in the armor plating: gray, yellow, green, and blue.

8. Add blue to the gray areas of the dinosaur on the left. Draw over the outlines of both dinosaurs with black.

Glossary

basic pencil: a hand-held instrument for writing, drawing, or marking. The lead in a basic pencil is made of graphite and clay.

carnivore: an animal that eats meat as its primary source of food.

colored pencil: a pencil with lead that contains a mixture of pigments and clay.

crosshatching: shading an area by first drawing parallel lines in one direction, and then drawing another set of parallel lines in a different direction over the top of the first lines.

graphite: a soft, black carbon substance.

herbivore: an animal that eats plant matter as its primary source of food.

highlight: a way of drawing attention to an object, making it stand out.

lead: the marking substance made of graphite and clay contained in pencils.

media: a combination of styles, methods, and materials used by artists. Paint, pencils, crayons, chalk, and clay are media.

paper stump: an instrument, usually cylinder-shaped with cone-shaped ends, used in drawing to blend lines.

parallel lines: lines that run next to each other and remain the same distance from each other for the length of the line.

pigments: substances that add color to another substance.

rivals: living beings that are in competition with one another.

stumping: in drawing, the process of gently pulling an eraser or paper stump across a drawing to blend and soften pencil marks.

vegetation: plant life.

Books and Videos for Further Study

Animals At A Glance: Dinosaurs and Other Prehistoric Animals. Flügel (Gareth Stevens)

The New Dinosaur Collection (series). (Gareth Stevens)

The New Dinosaur Library. Dixon (Gareth Stevens)

Worldwide Crafts (series). Deshpande and MacLeod-Brudenell (Gareth Stevens)

Dinosaur! An Amazing Look at the Prehistoric Giants. (Children's Video Library)

Life on Earth: Victors of Dry Land (Episode 7). (MacArthur Foundation Library Video)

Index

Ankylosaurus 28-31

Brachiosaurus 8-11

clay 4
crosshatching 6, 7, 17, 29

erasers 5, 8, 12, 13, 16, 20, 24, 28

graphite 4

Iguanodon 16-19

media 4

Pachycephalosaurus 28-31
parallel lines 6, 7, 9, 13, 28
pencils, basic 4, 5, 6, 7, 8-11, 12-15, 16, 20, 24, 28
pencils, colored 4, 7, 16-19, 20-23, 24-27, 28-31

pigments 4

shading 6, 8, 10, 14, 16, 17, 18, 21, 25, 26, 27, 29
stumping 5, 6, 12, 13, 15
Stygimoloch 24-27

Tsintaosaurus 12-15

Velociraptor 20-23

The Date Due Card in the pocket indi-
cates the date on or before which this
book should be returned to the Library.

Please do not remove cards from this
pocket.